# My Trip to Paris Coloring Book

An adult coloring book, Inspired by the city of Paris
Over 30 illustrations for hours of stress relieving fun!

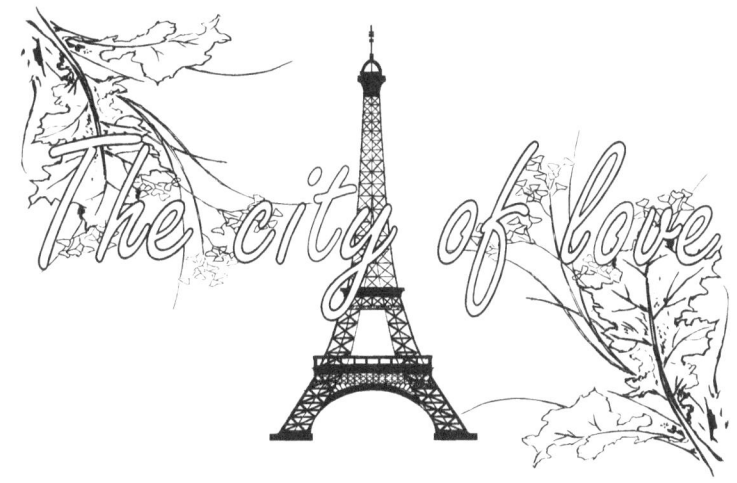

Be sure to check us out on Facebook and our website for other great things!

http://breerspublishing.weebly.com/

https://www.facebook.com/BreersPublishing/

Images in this book are created from public domain creative commons or royalty – free vintage art. Copyright 2016 Breer's Art & Things Vintage publishing. All rights reserved. No part of this book may be reproduced or transmitted in any form by any means, electronic or mechanical, including photo-copying, scanning and recording, or by any information storage system, without permission in writing from the publisher, except for the review and/or inclusion in a magazine, newspaper, distribution outlets, and broadcasts.

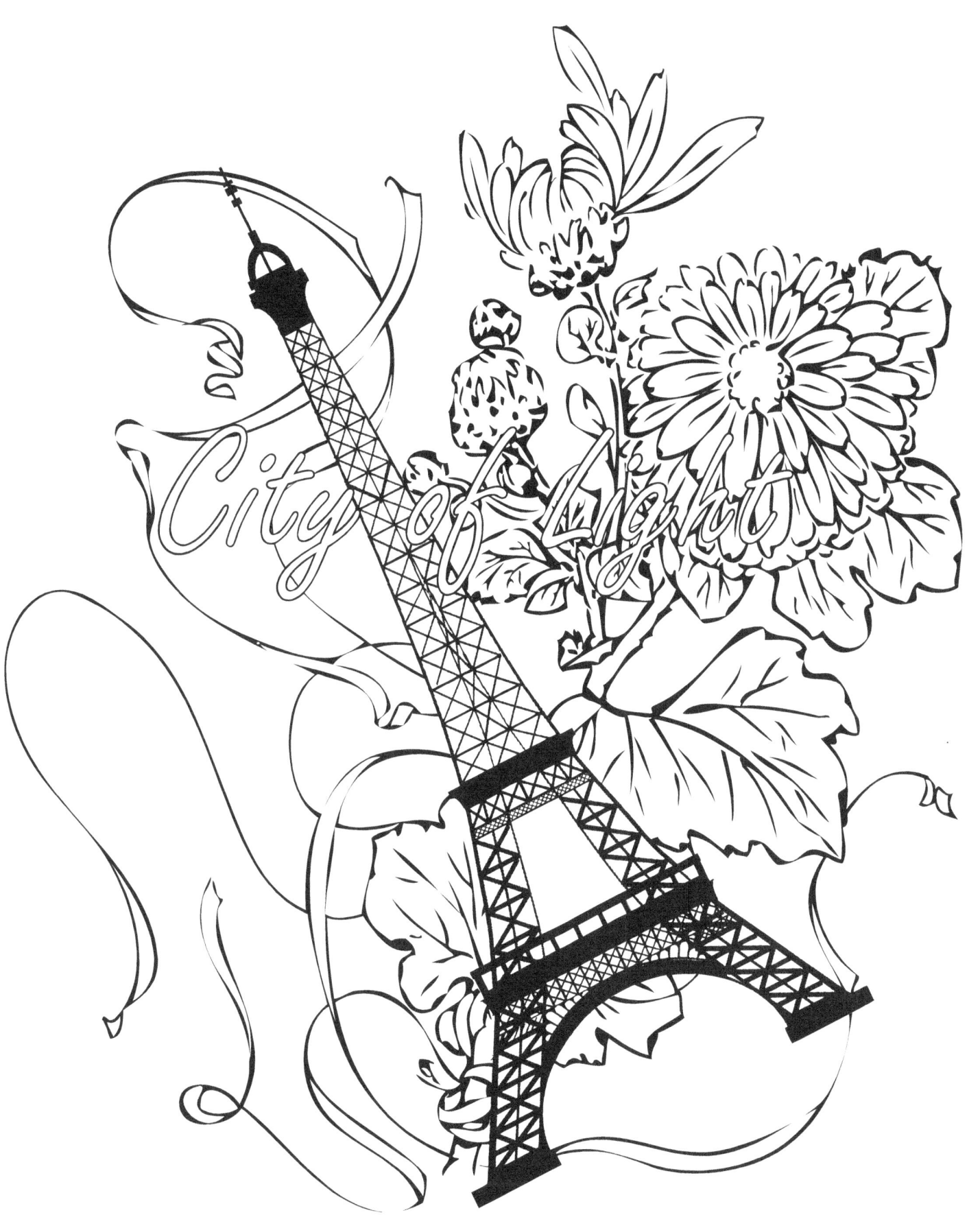

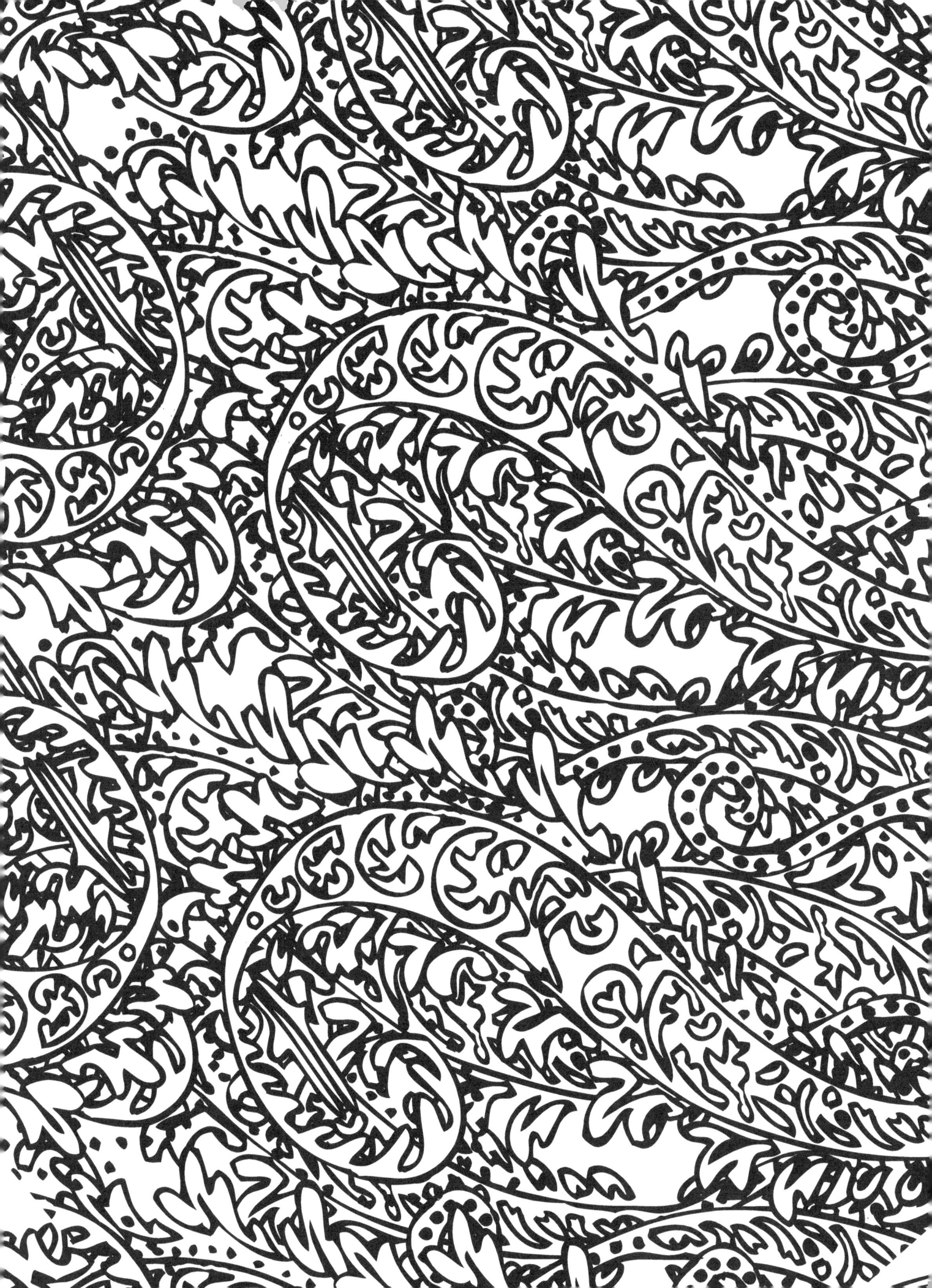

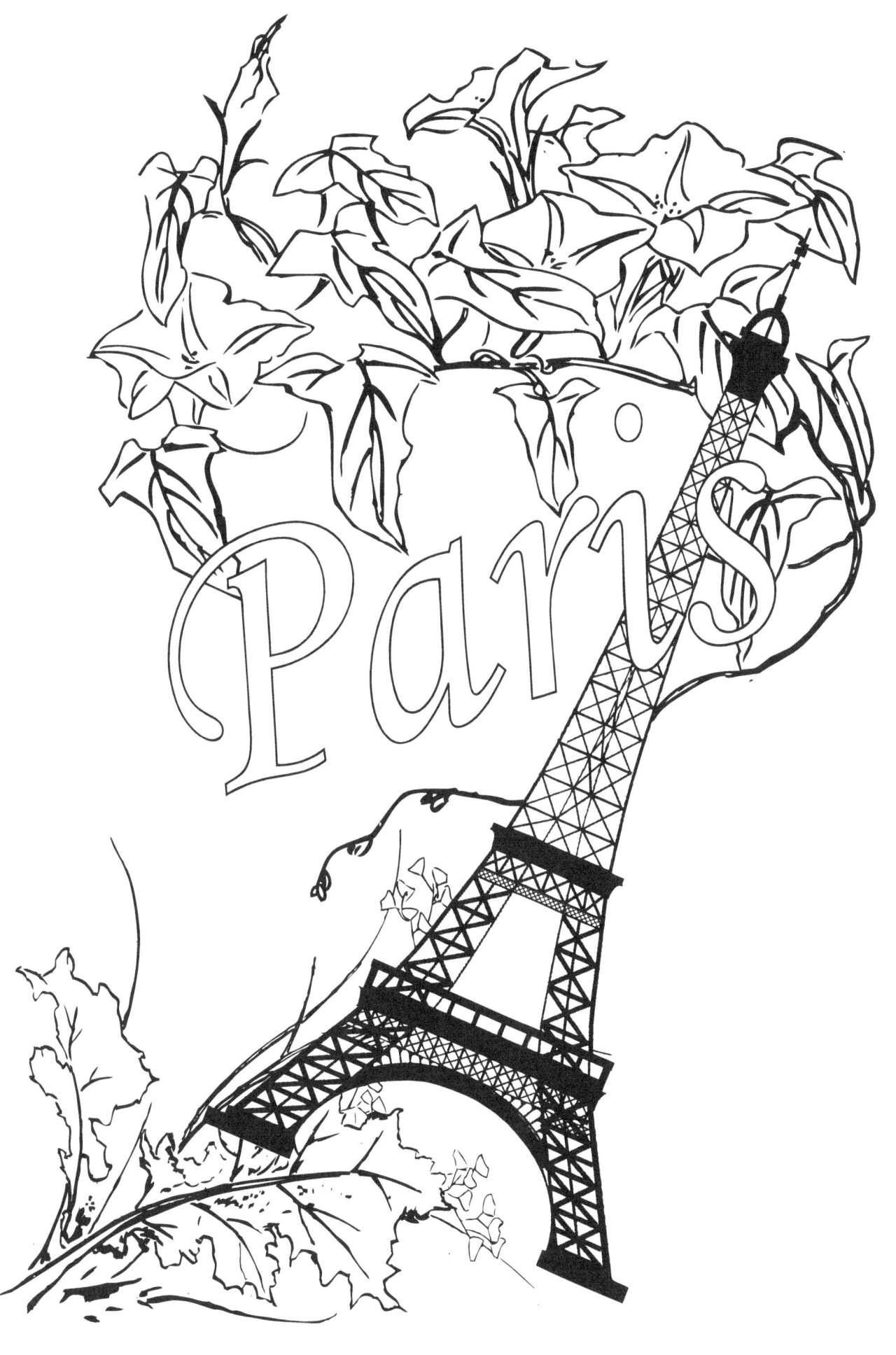

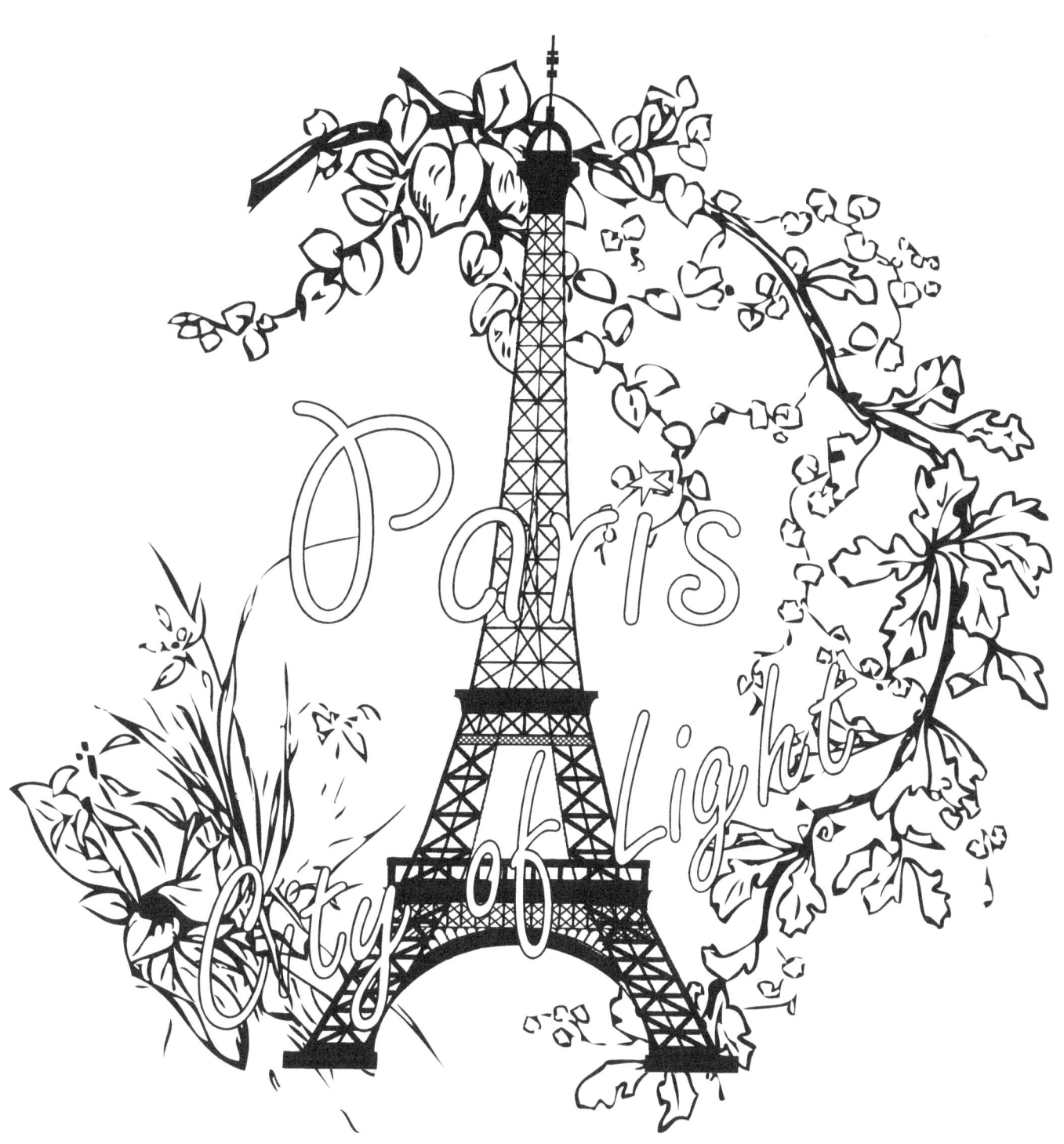

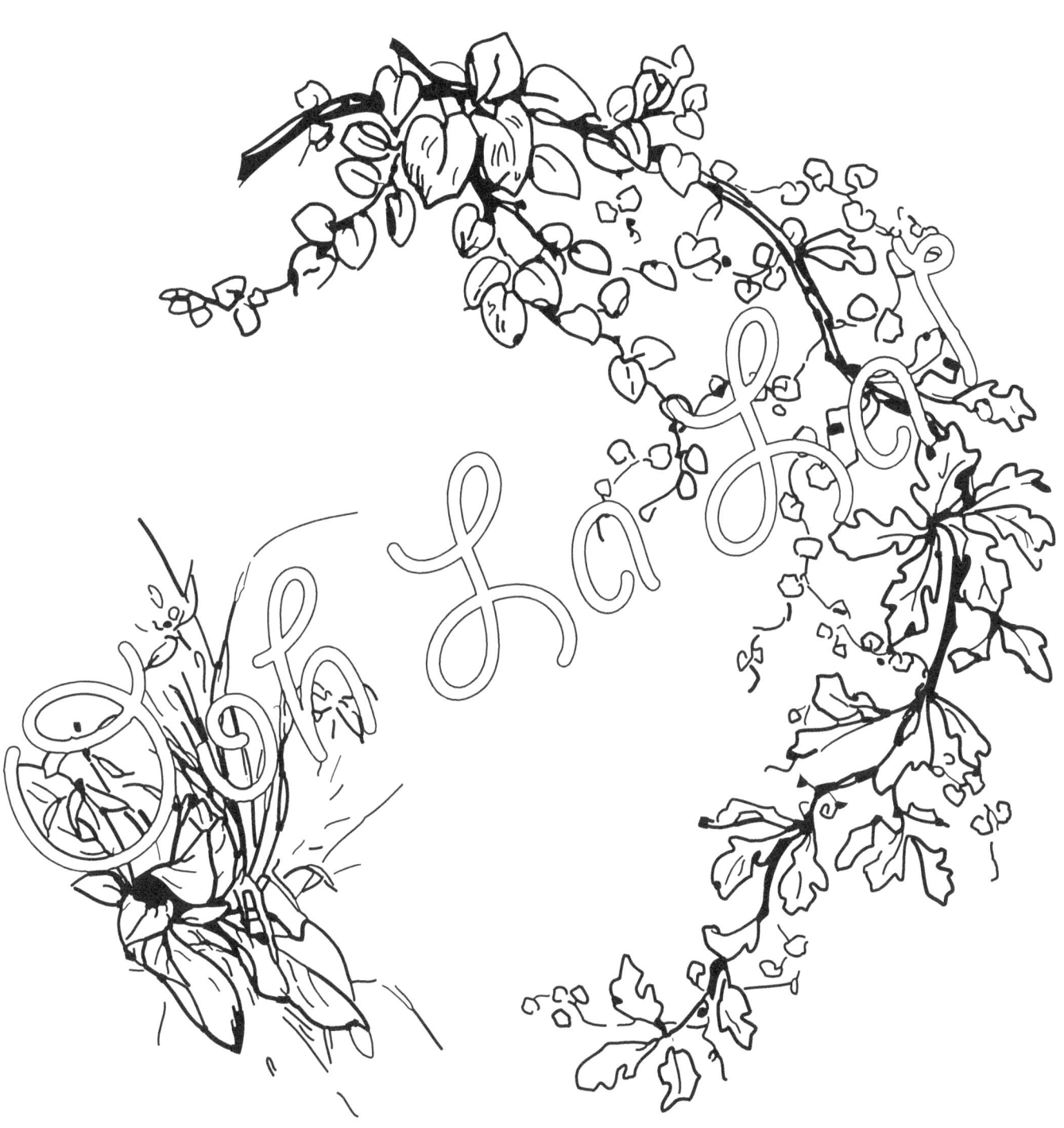

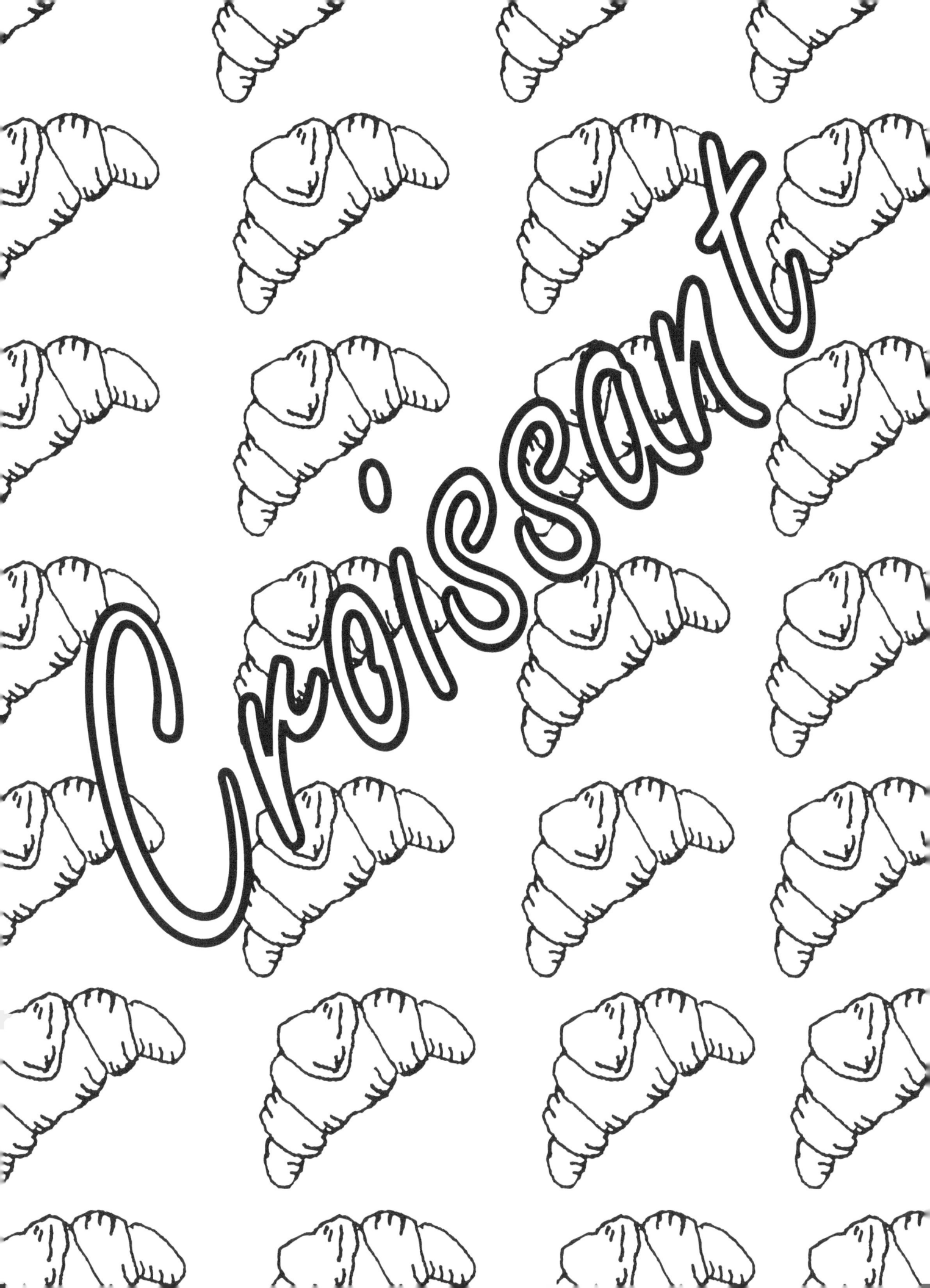

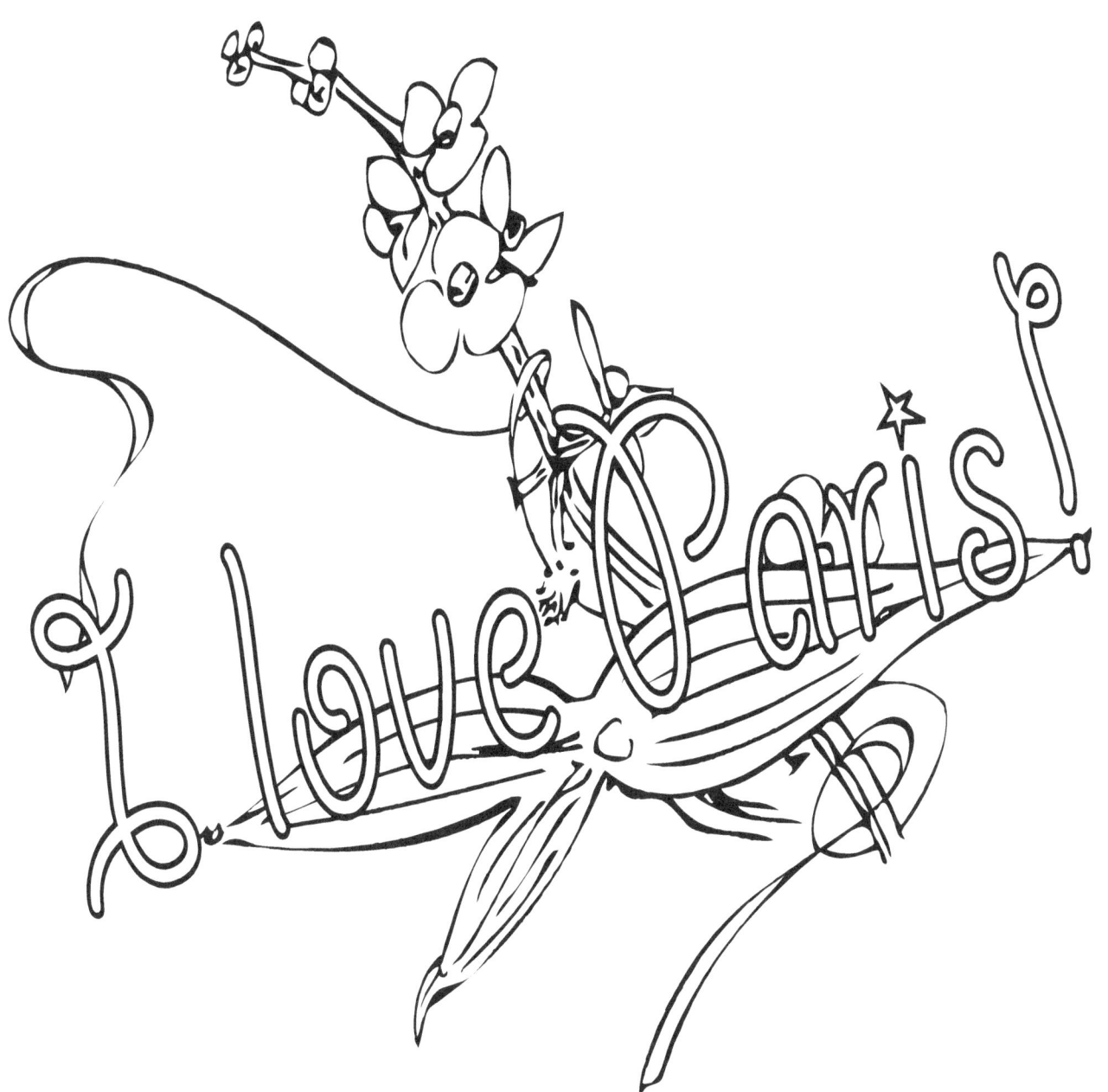

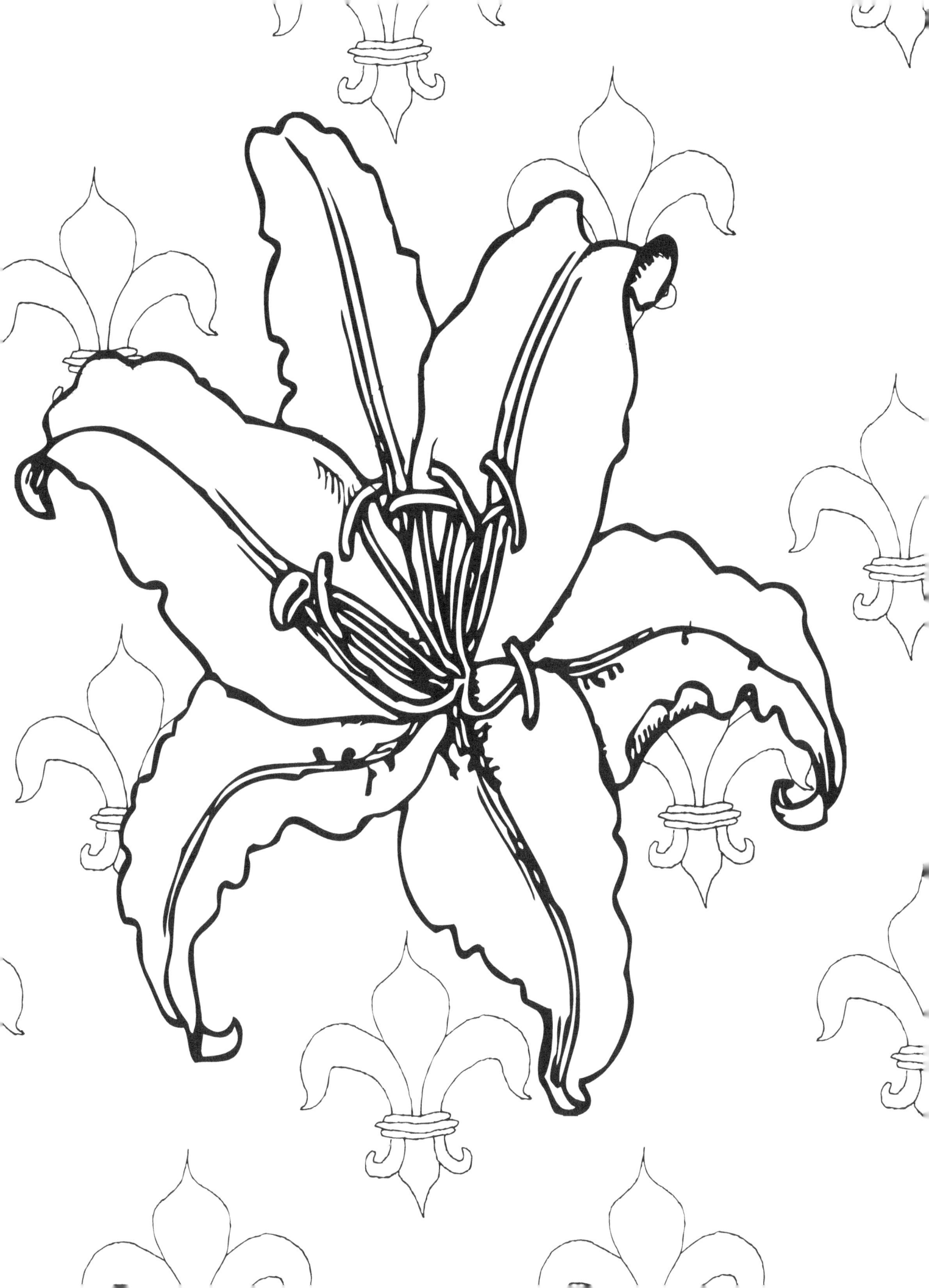

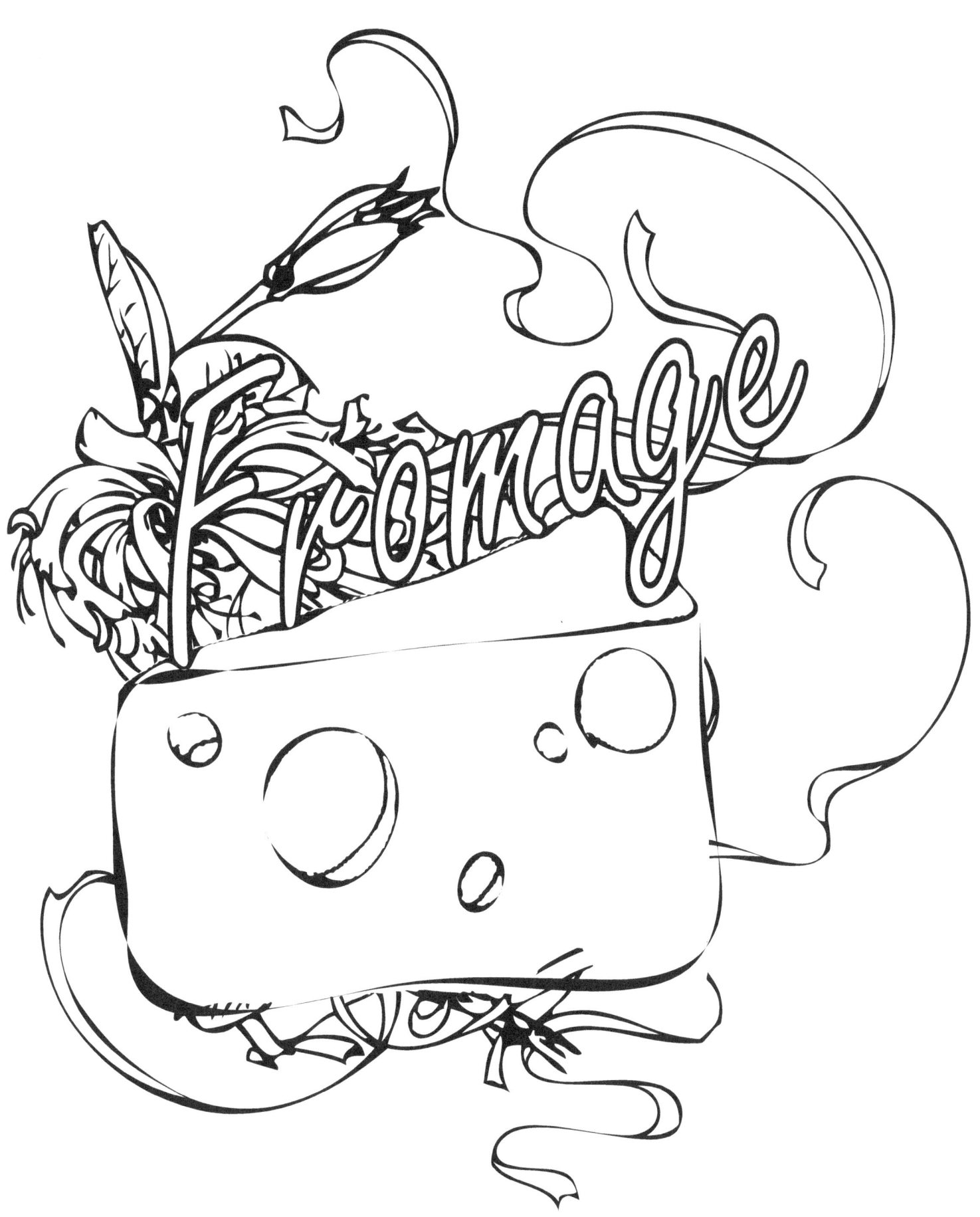

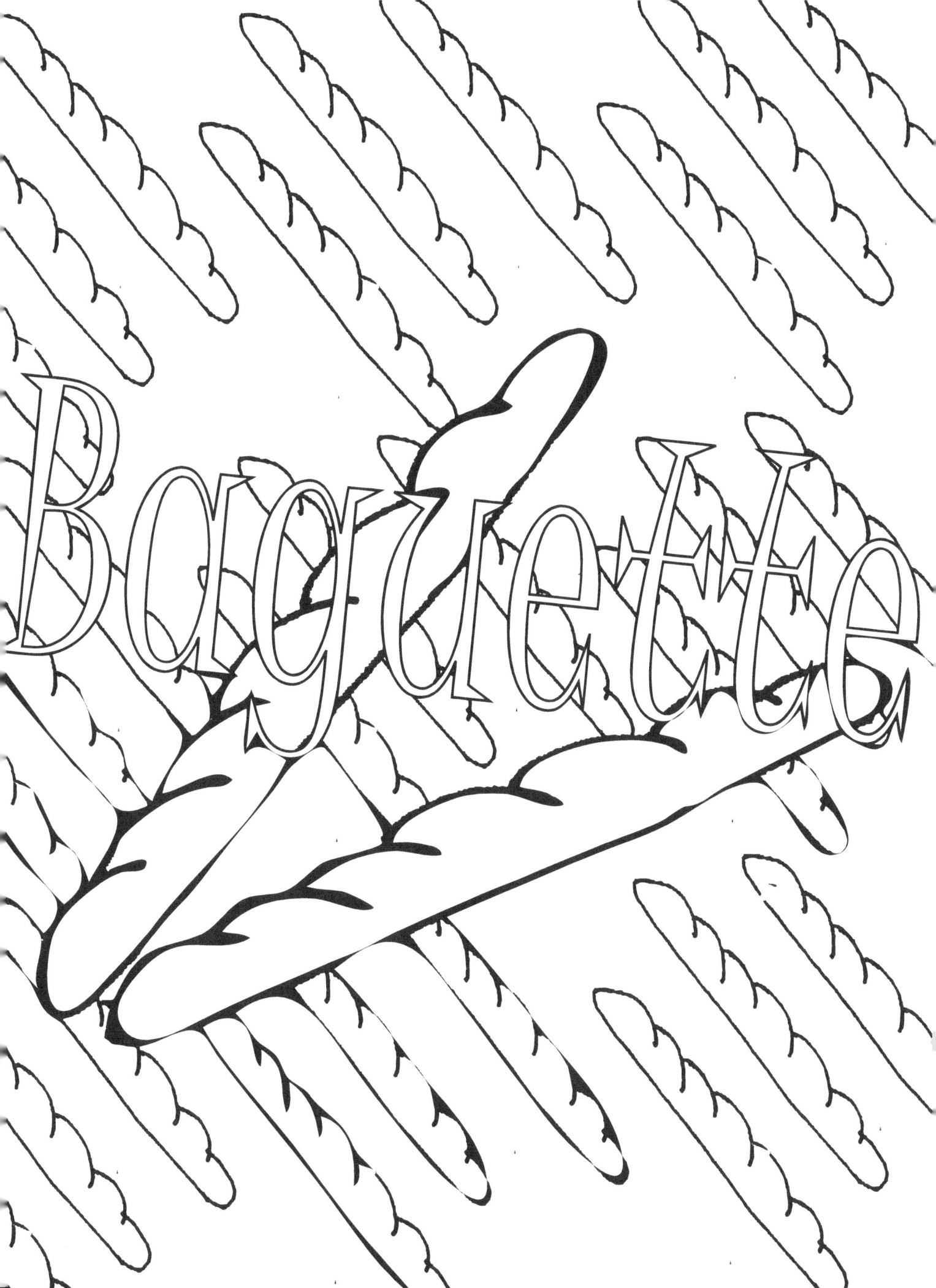

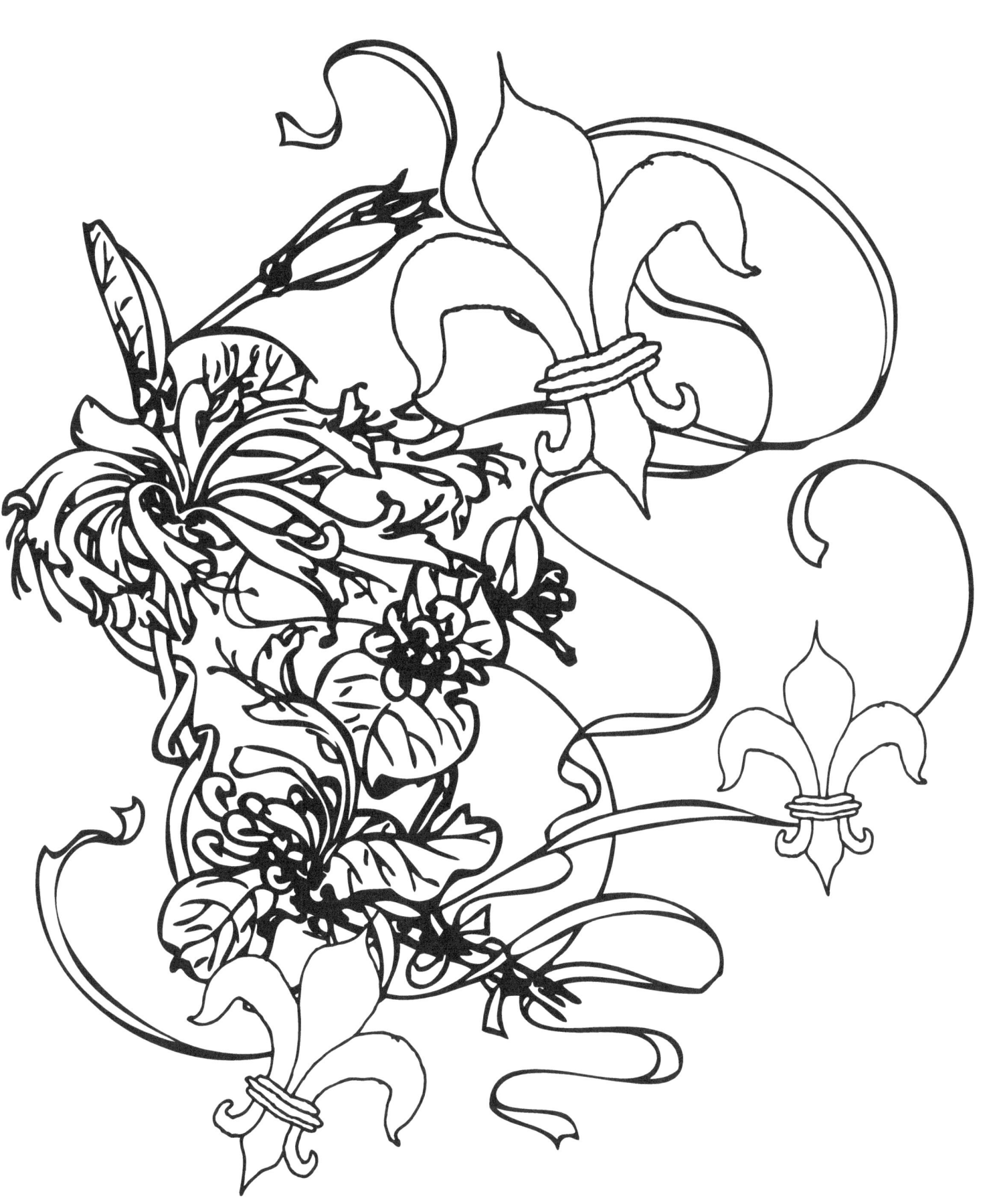

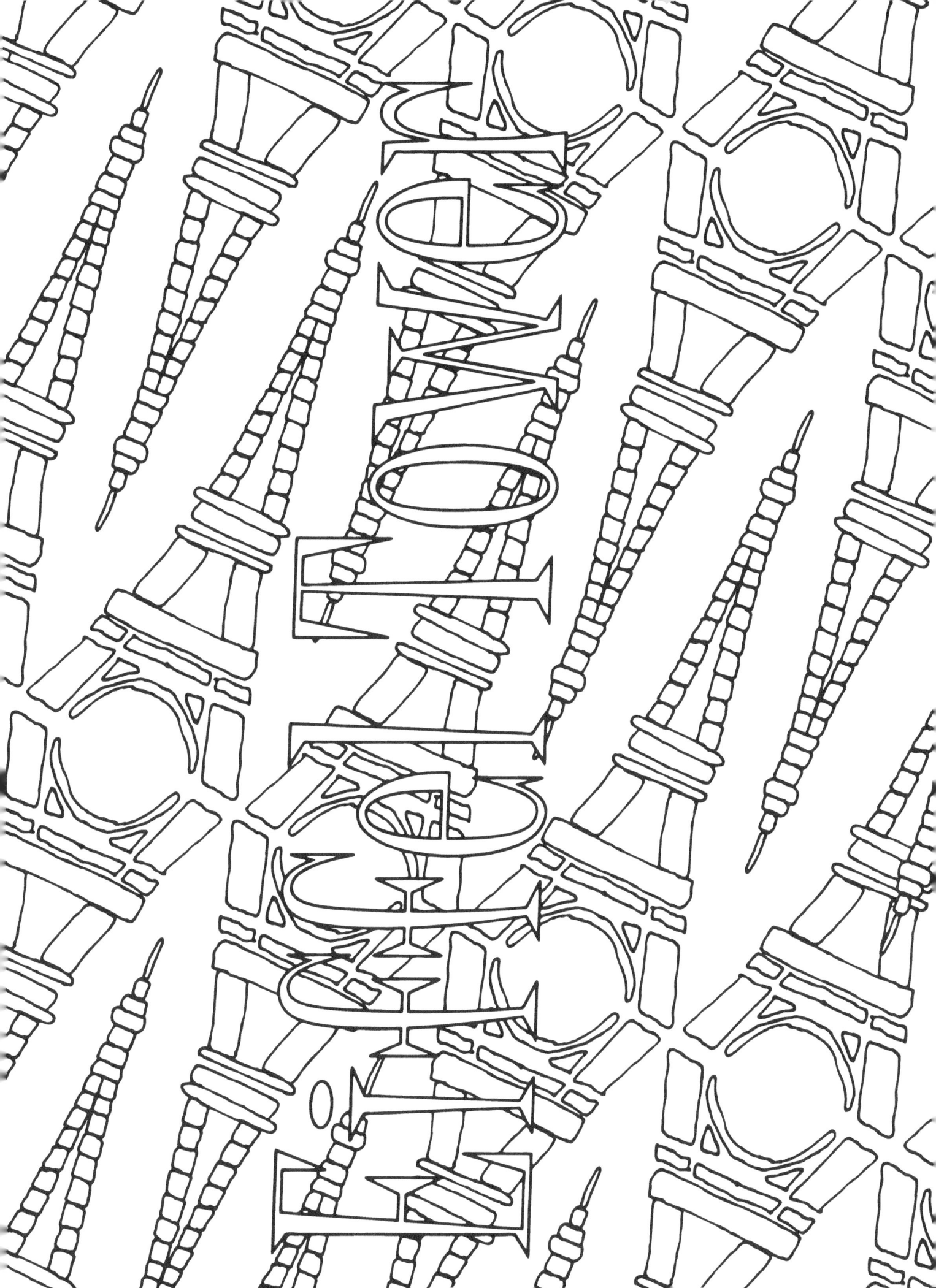

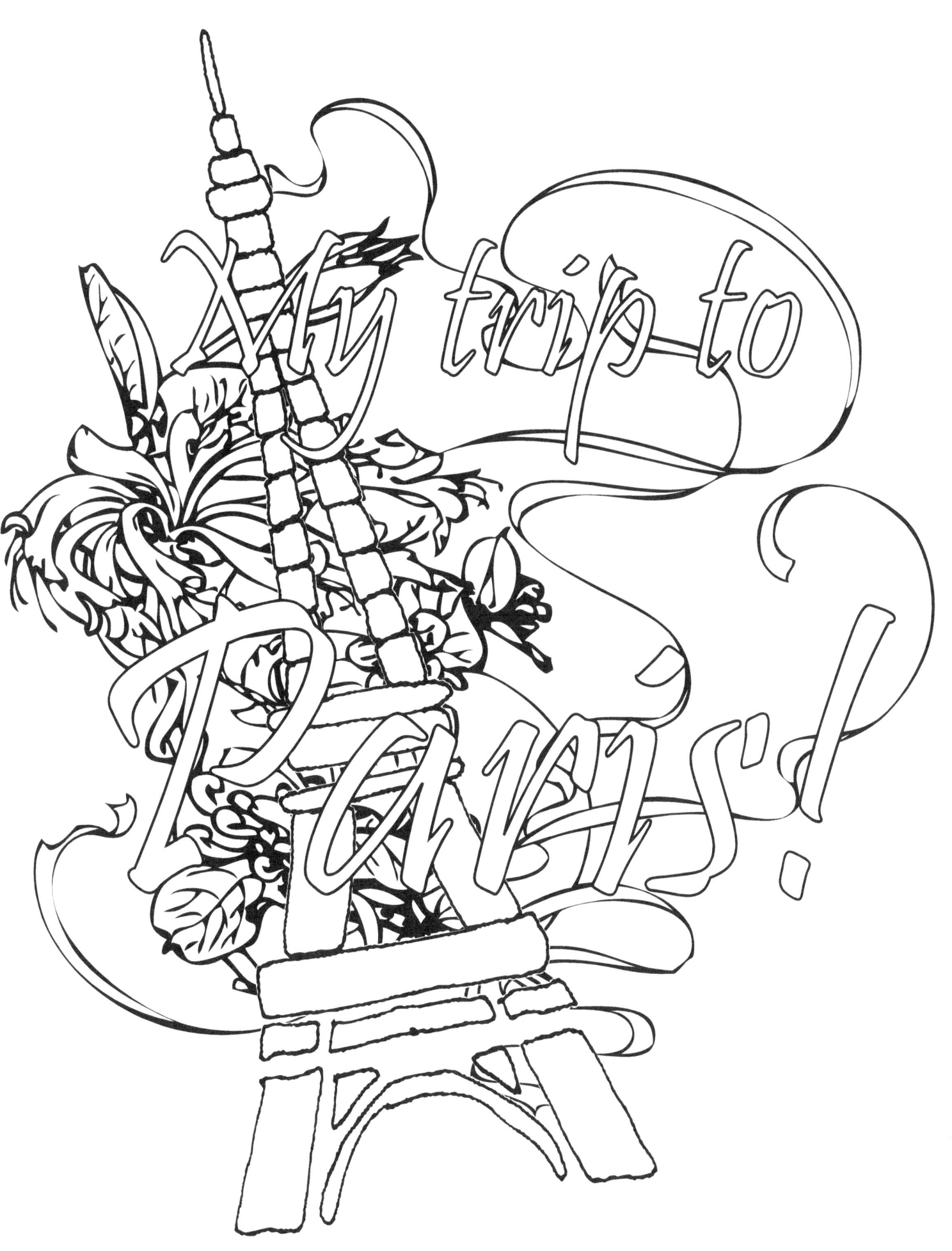

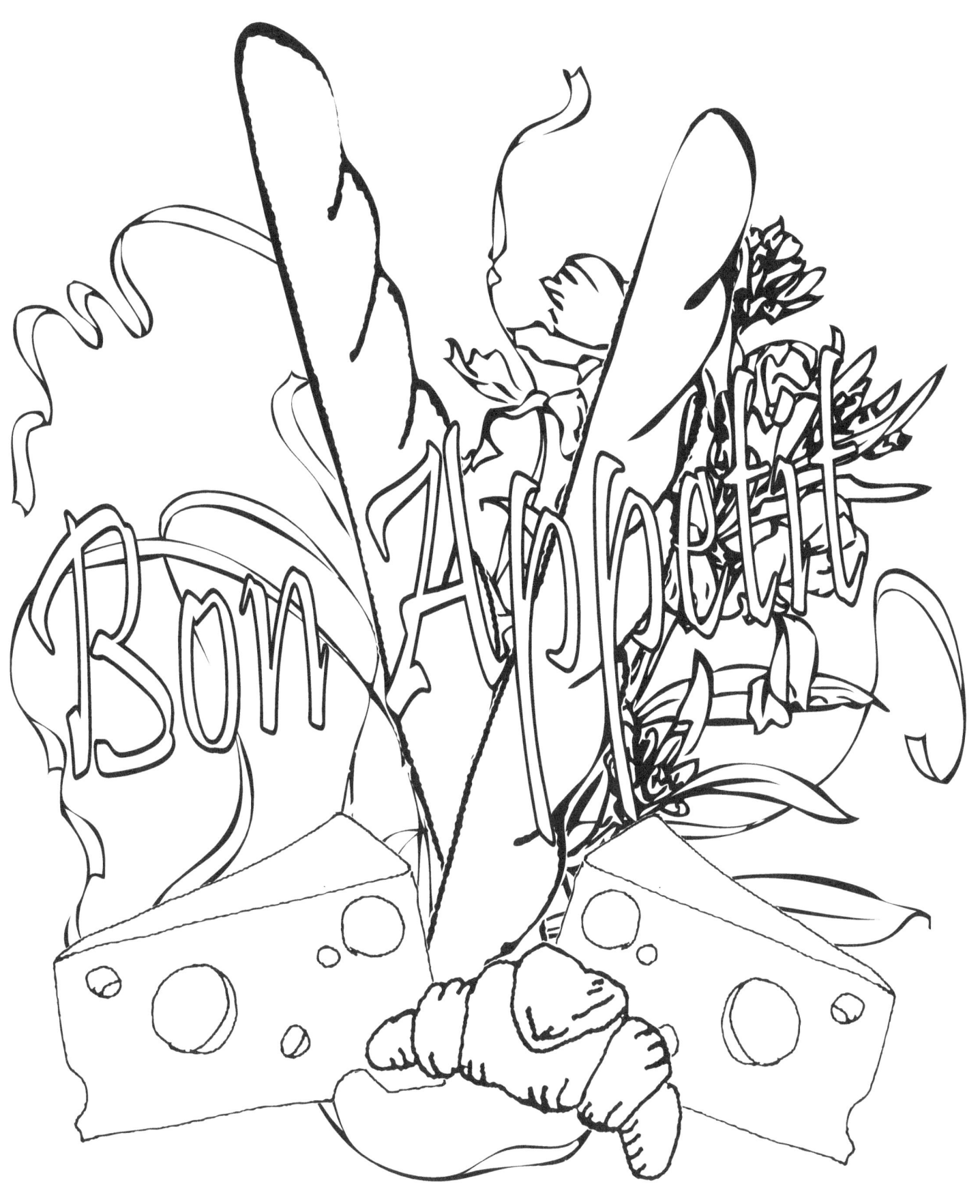

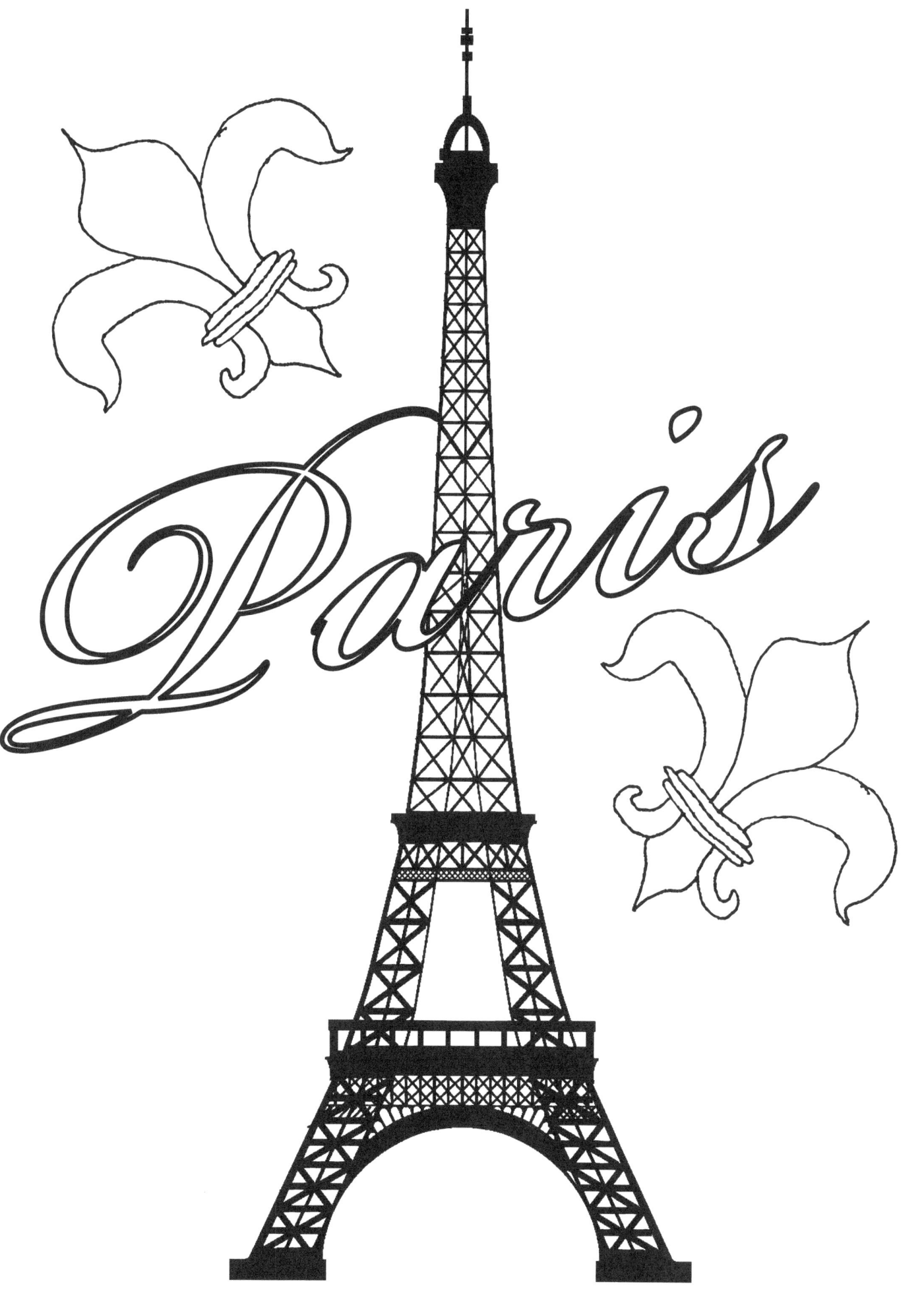

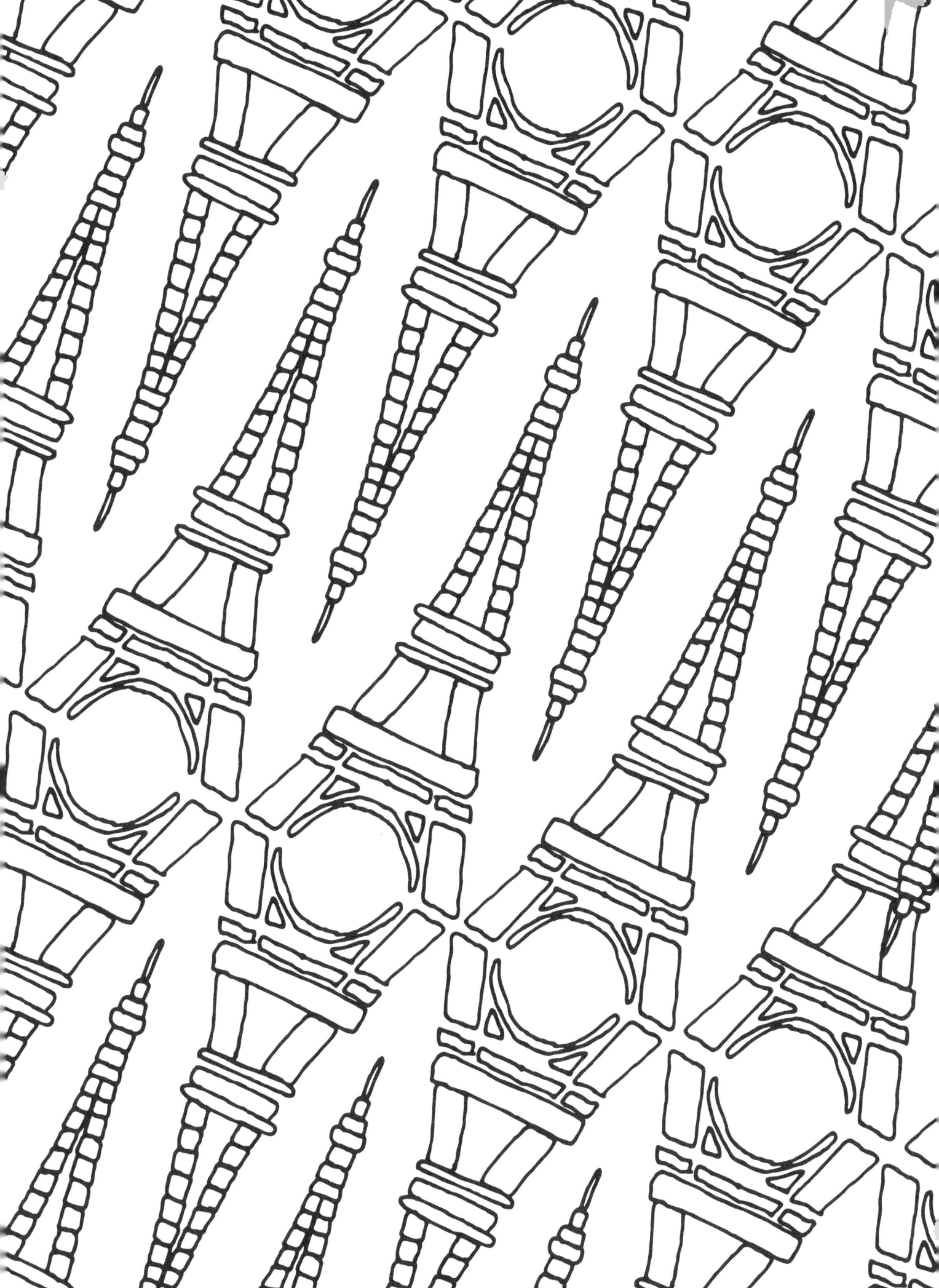

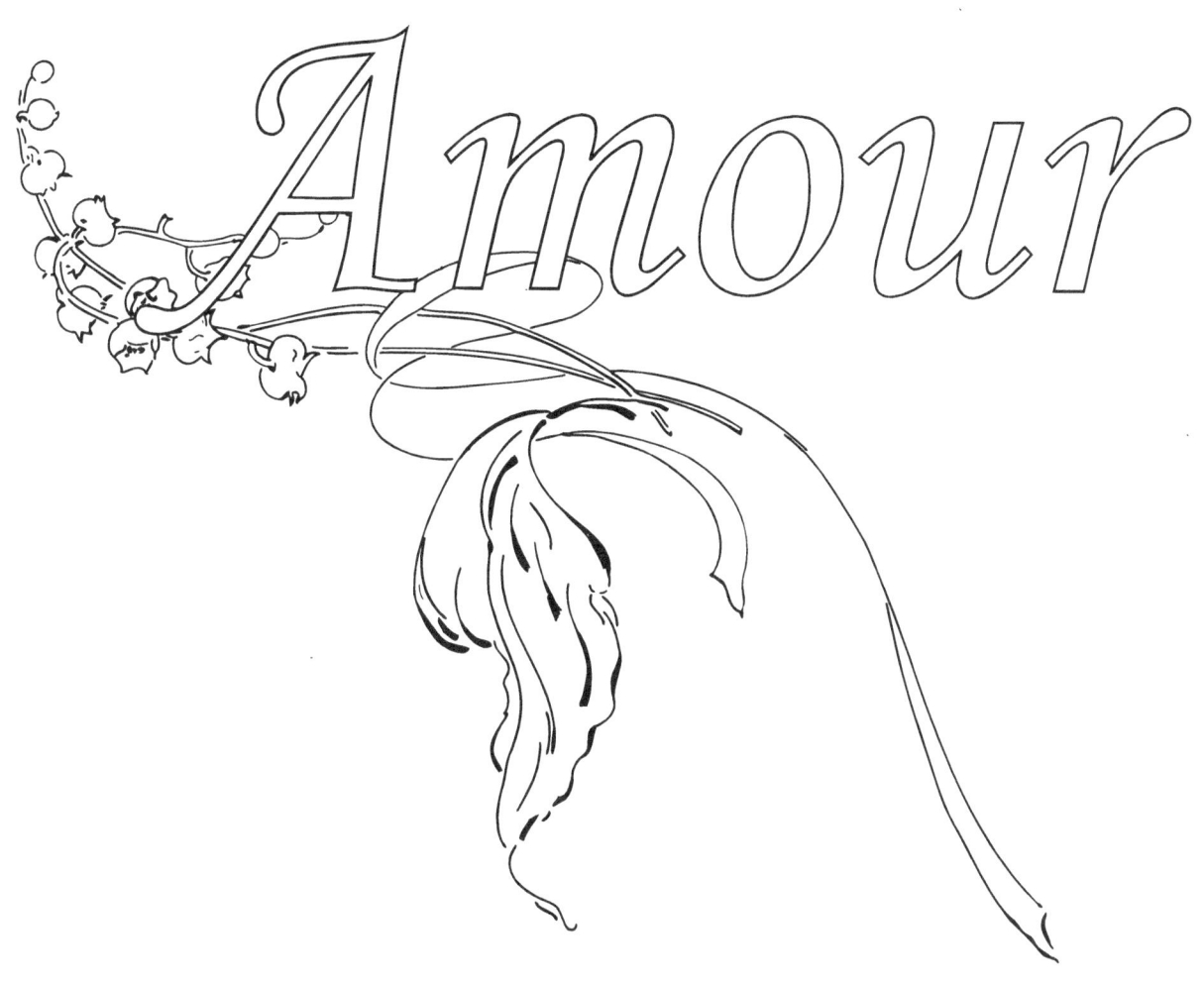

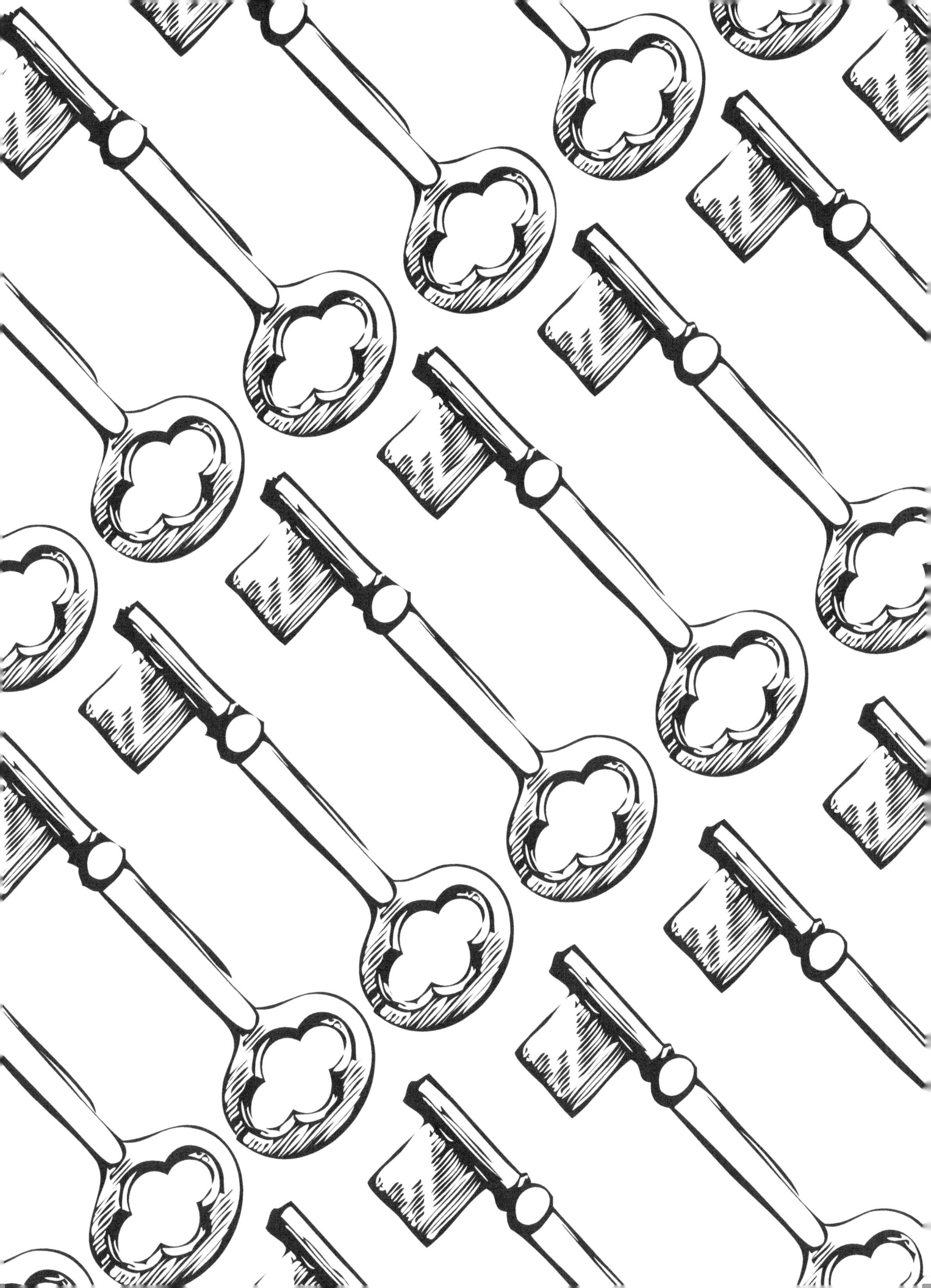

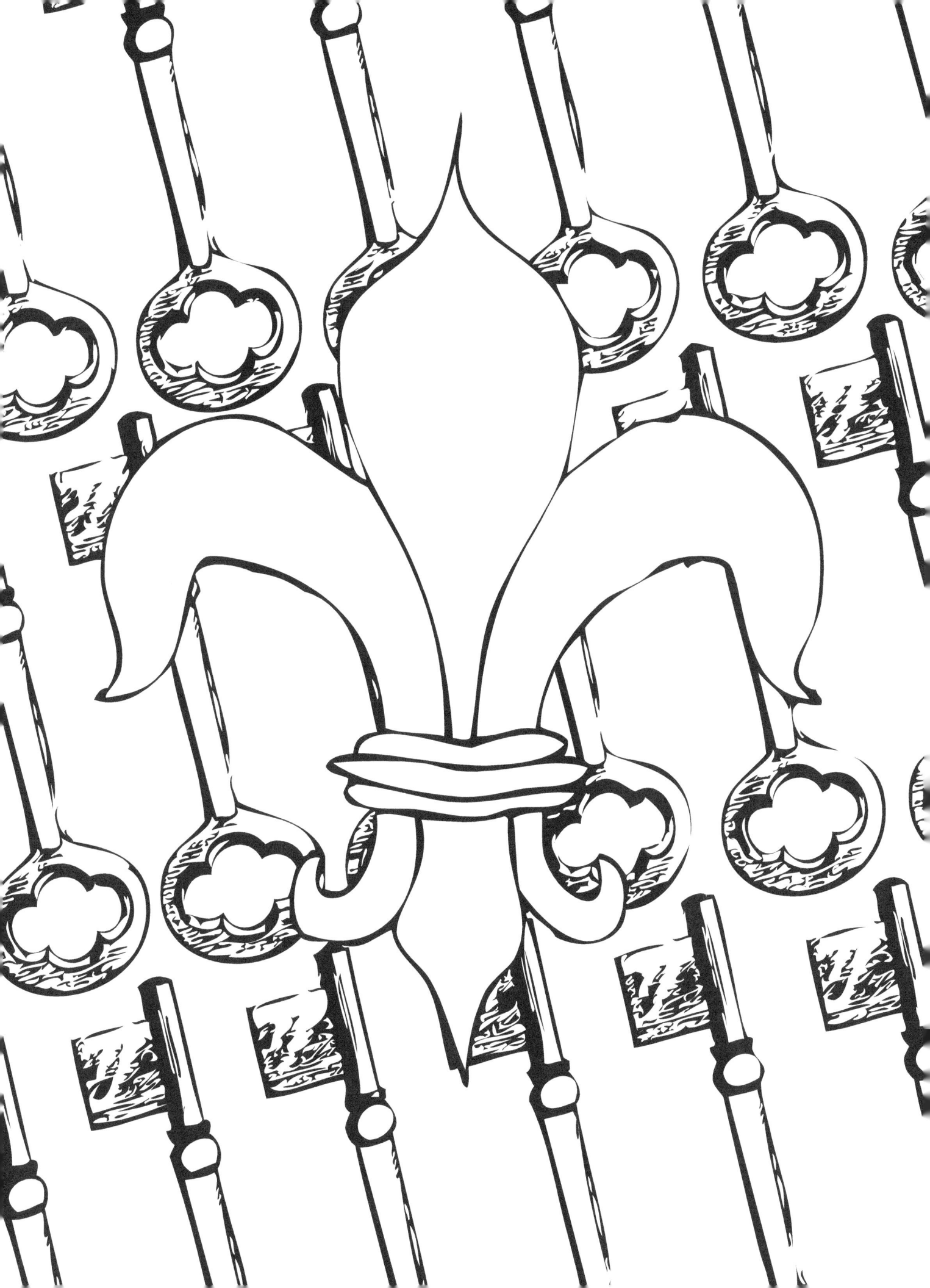

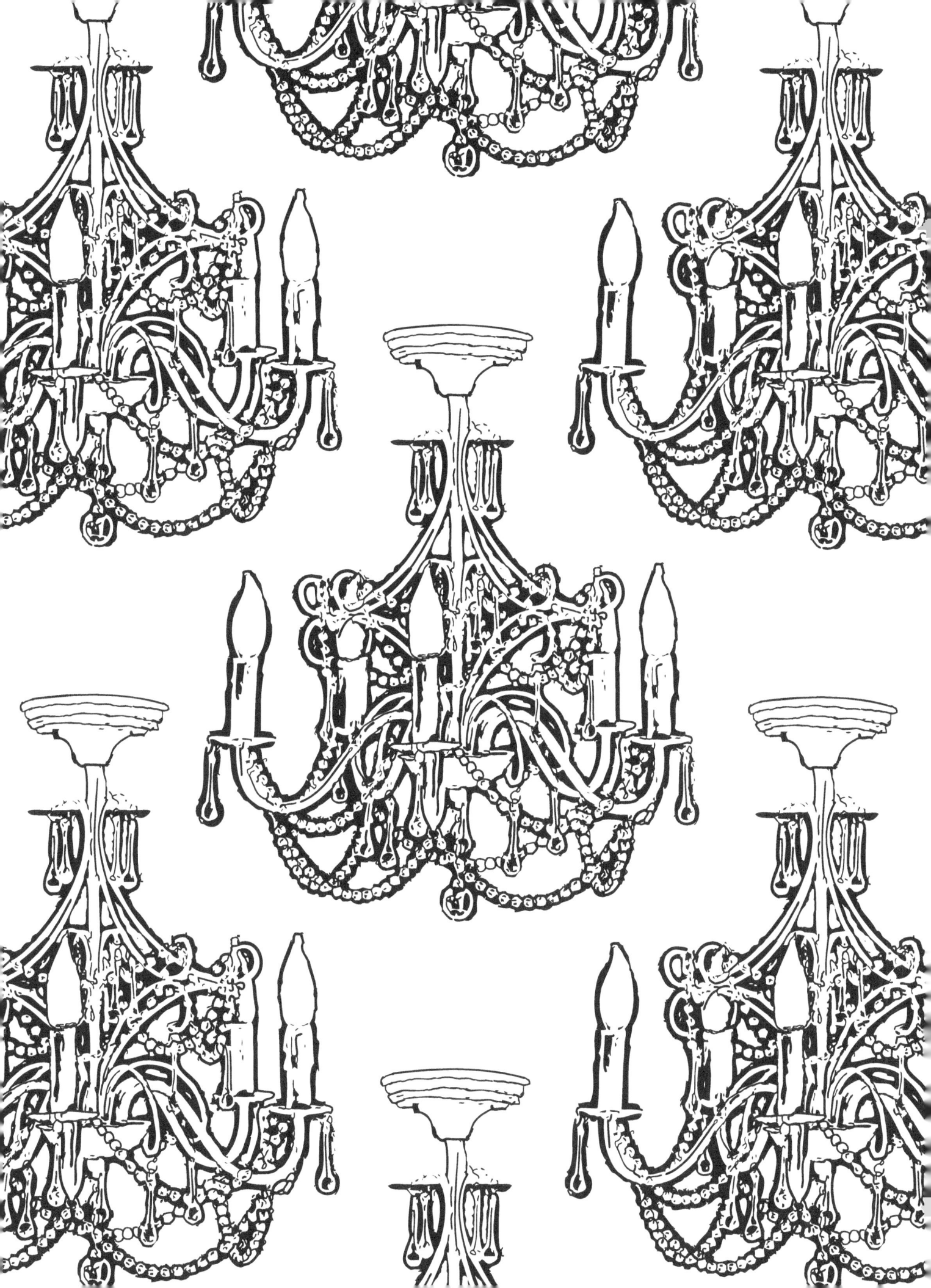

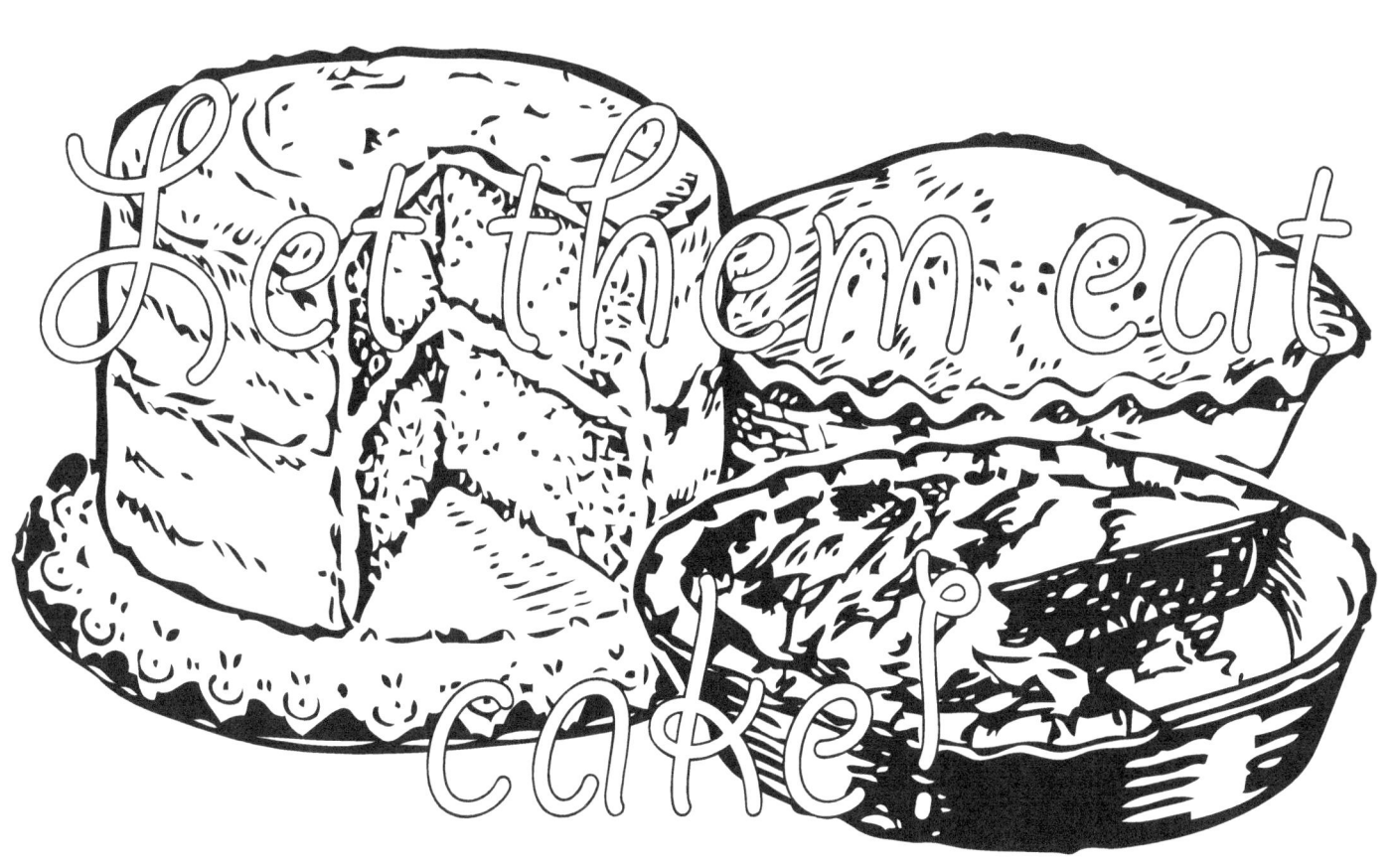

www.ingramcontent.com/pod-product-compliance
Lightning Source LLC
Chambersburg PA
CBHW080542190526
45169CB00007B/2603